What you'll need to get started...

a pencil

a black permanent marker
Micron 01 Pigma pigment ink pen
by Sakura is suggested

smooth art paper
a 3^1/$_2$" x 3^1/$_2$" 'tile' is suggested

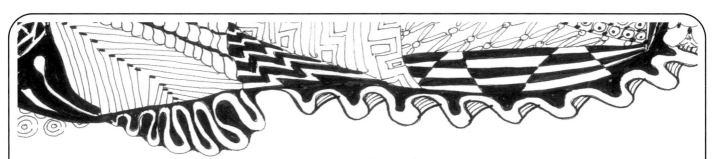

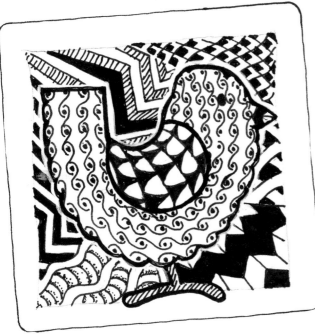

for Children

Level of Difficulty: All Levels, ages 5 and up

Zentangle can be done by almost any age... children, teens and adults.

Most younger children find it easier to draw big while they are still developing dexterity. To begin, I recommend a black 08 Pigma pen. For paper, I use 5^1/$_2$" square white cardstock.

Teens and tweens love to draw Tangles. A black Micron 08 Pigma pen works well, and students feel totally comfortable with 3^1/$_2$" tiles, 5^1/$_2$" tiles, or 8^1/$_2$" square tiles.

TIP: Sturdy paper such as 60# cover or 100# cardstock works well.

How to Get Started...

1. Use a pencil to make a dot in each corner.

2. Connect the dots.

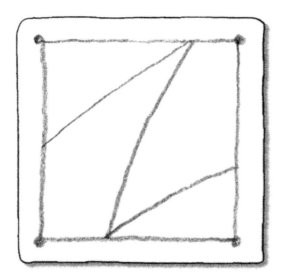

3. Draw a "string" as a guide line. Try a
Z zigzag, a ⟩ loop, an ✕ 'X' or a swirl.

Traditional Zentangles...

A very simple process is part of every traditional Zentangle.

1. Make a dot in each corner of a paper tile with a pencil. Connect dots to form a basic frame.

2. Draw guideline "strings" with the pencil. The shape can be a zigzag, swirl, X, circle or just about anything that divides the area into sections.

It represents the "golden thread" that connects all the patterns and events that run through life.

The lines will not be erased but become part of the design.

3. Use a black pen to draw Tangle patterns into the sections formed by the "string".

4. Rotate the paper tile as you fill each section with a pattern.

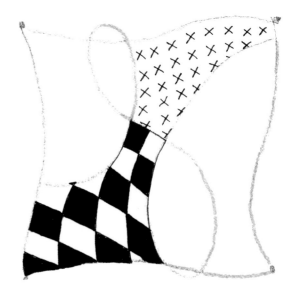

4. Switch to a pen and draw tangle patterns into the sections formed by the "string".

Tips...
• When you cross a line, change the pattern.
• It is OK to leave some sections blank.

TANGLES

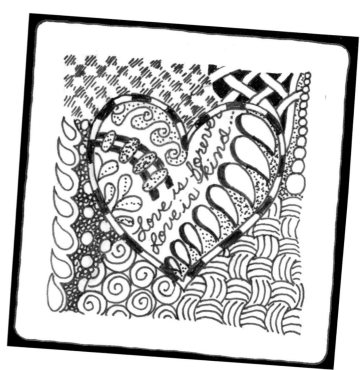

Each Tangle is a unique artistic design and there are hundreds of variations. Start with basic patterns, then create your own.

With Zentangle, no eraser is needed. Just as in life, we cannot erase events and mistakes, instead we must build upon them and make improvements from any event.

Life is a building process. All experiences are included into our learning process and into our life patterns.

 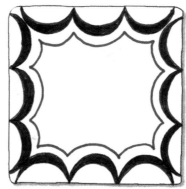

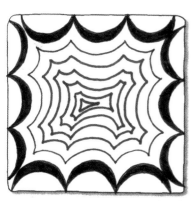

Crescent Moon*

1. Draw curved humps along the inside edges of any section.

2. Draw a curved line on each hump to create arches or moon shapes.

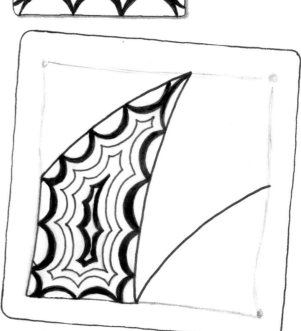

3. Color each moon with black.

4. Draw a continuous curved line inside of the moons.

5. Draw additional curved lines to fill the section.

*original Zentangle design - Variation

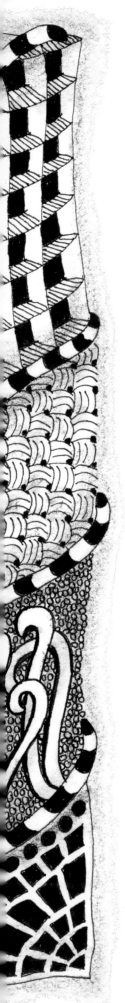

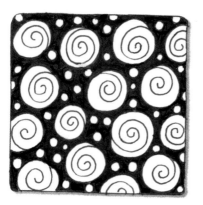

Printemps*

1. Draw a small spiral, sort of like a cinnamon bun or jelly roll. Start with a small "C" shape then spiral around it and close the end of the spiral.

2. Make more spirals to fill the section.

3. Add small circles to fill spaces in the section.

4. Color the background with black.

*original Zentangle design - Variation

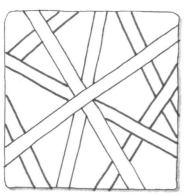 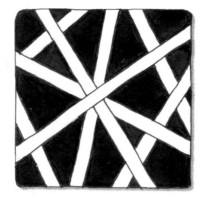

Hollibaugh*

1. Draw two parallel lines across a section.

2. Rotate the tile then draw another pair of lines letting the shape appear to go "behind" the first one.

3. Rotate the tile again and draw another pair of lines that goes under. Rotate and repeat until the section is filled.

4. Color the background with black if desired.

*original Zentangle design

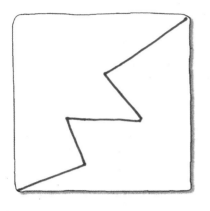
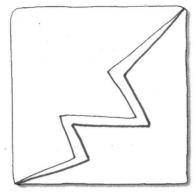
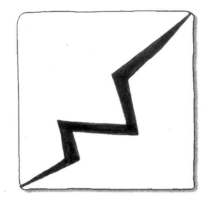

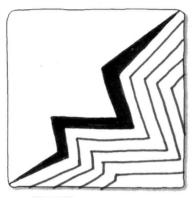
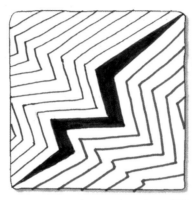

Static*

1. Draw a zigzag line from one corner of a section to the other side.

2. Draw a second zigzag line parallel to the first one (let the lines join at the ends).

3. Color the zigzag shape with black.

4. Draw on the right side of the black bolt to add an echoing line (don't let the lines join at the ends). Draw additional zigzag lines to fill the section.

5. Turn the tile and draw on the other side of the black bolt to fill the section.

 Tip: If you are left-handed, draw on the left side.

*original Zentangle design - Variation

Shading Your Zentangle

 Shading adds a touch of dimension.

1. Use the side of your pencil to gently color areas and details with gray.

Suggestions of where to add shading…

• In the center of the Moon Walk section

• On one side of each Spiral

• On the right and left of the first set of parallel lines

• On the lower zag of each parallel zigzag line

• Along the edge of some sections to add depth to the sections of the design

• Along the right edge and the bottom of your finished shape, about 1/8" wide, to "raise" it off the page

 Note: Use shading sparingly.

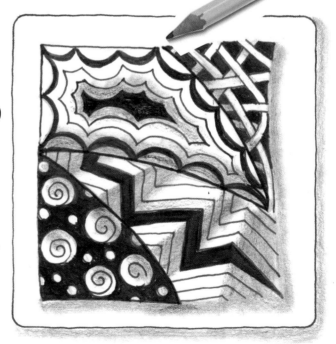

Use the pencil to add shading and use a paper stump to rub the pencil to smudge and blend the gray areas.

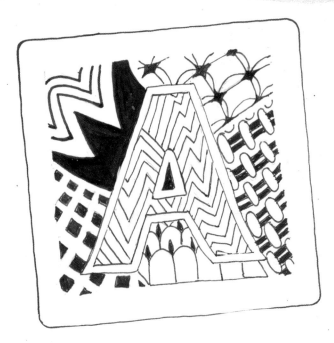

Alphabet

Draw a block letter, it could be your initial or part of a word. Draw sections within the letter and/or sections around the border. Then add a pattern in each section.

Tip: Spell a word or your name by lining up three or more tiles.

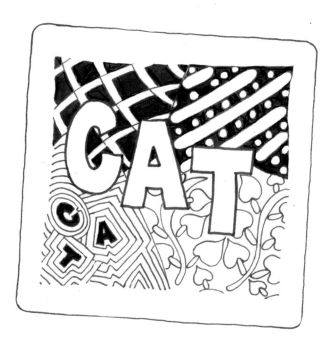

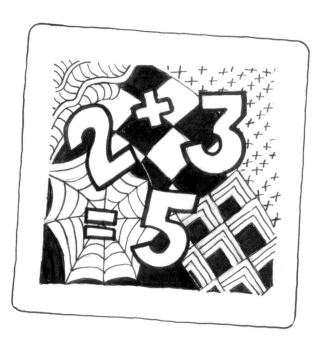

Relate Zentangle to Learning...

Here's a neat trick to increase spelling comprehension. Spell out a word in block letters within a tile. Add letters in a section and fill the section. As you draw, your mind will be recording the sequence of the letters.

Here's a clever way to help memory in math. Draw your addition numbers then add patterns in the background.

What You'll Learn from Zentangle...
- Hand-to-eye coordination
- Manual dexterity
- Follow instructions
- Complete each step
- Problem solving
- Turn mistakes into positives
- Creativity and innovation

Geometry

Learn basic shapes in patterns... circle, square, triangle, spiral.

Friendship Tangles

Draw on a large piece of cardstock. Add the "string" and make many sections (at least one for each friend). Ask each person to draw a pattern in a section.

At the end you'll have a wonderful piece of art created by many hands and talents.

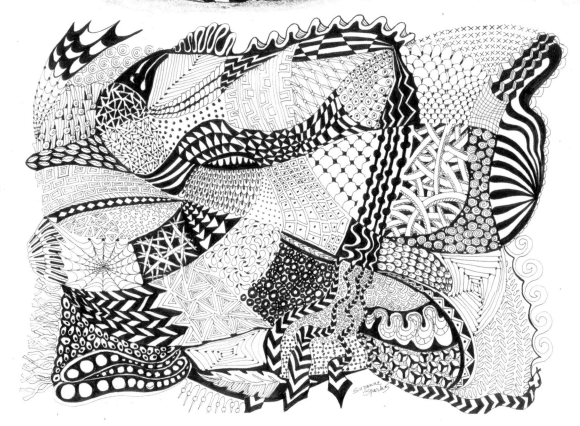

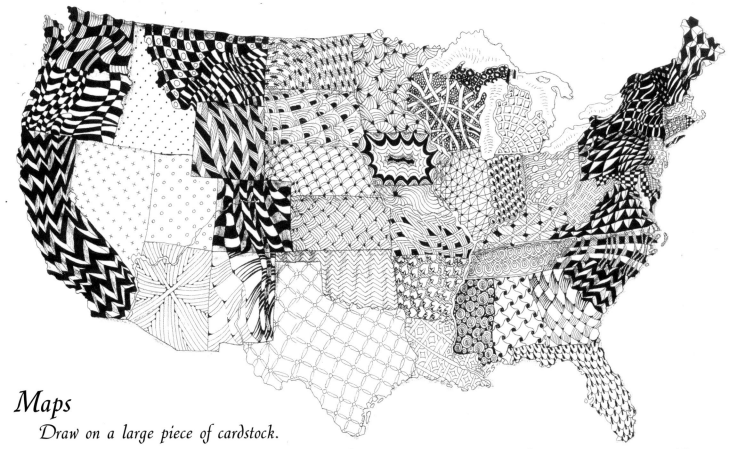

Maps

Draw on a large piece of cardstock.

For the string, use an outline of the states. Give each student a copy of the map. Each day fill in a state with a pattern. This fun project helps students memorize the shape and position of states on the map. At the end, every state will be filled.

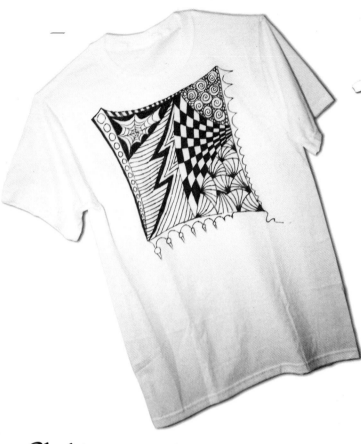

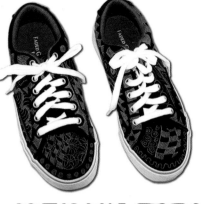

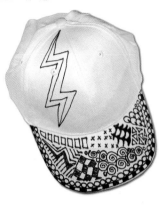

Clothing

Draw on clothing to wear and to share your creations.

• T-shirts make a wonderful background. Tip: Iron freezer paper on the back of the design area of the shirt to hold the fabric. Draw with a black permanent pen, pull off the freezer paper, then iron the shirt to 'set' the ink.

• Canvas tennis shoes work great. Draw with a black permanent pen on white shoes, or with a white gel pen on black shoes.

• A fabric ball cap (or foam visor) can be decorated and worn anywhere.

Zen-mandala

Draw circles with a pencil then divide them into sections.

Draw in the sections with a pen.

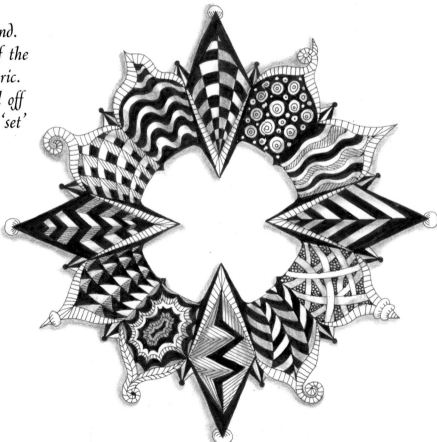

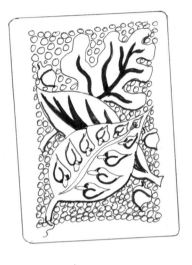
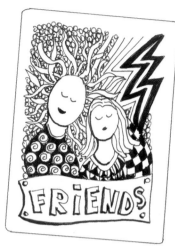

Artist Trading Cards

ATCs are fun to share with friends.

Draw designs on a 2 1/2" x 3 1/2" piece of cardstock. Sign your name and date on the back, then trade the cards with friends.

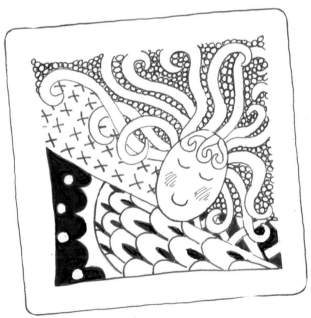

Notebooks & Pages

Draw fun designs in your spare time. Decorate a notebook with your name and patterns.

Tangle on the edges of pages to add decorations.

Drawings of Friends

Add hair designs to photos of your friends and family... even your dog or cat.

I like to combine patterns with watercolor to create large paintings. You can also use color inks, watercolors, watercolor pencils, markers or any method that works.

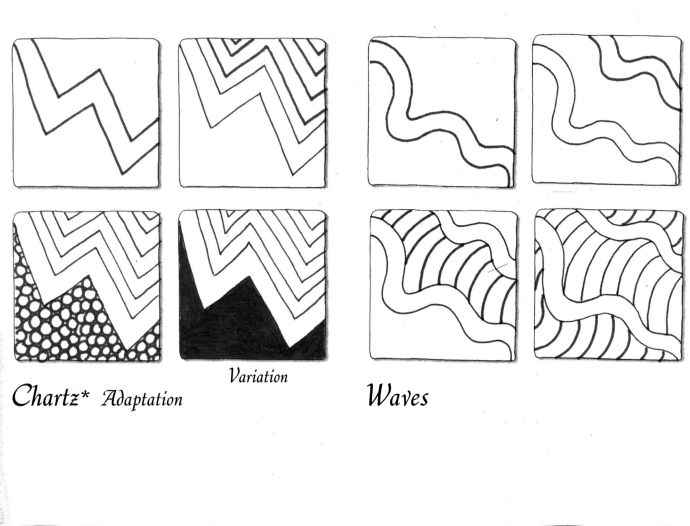

Chartz* Adaptation

Variation

Waves

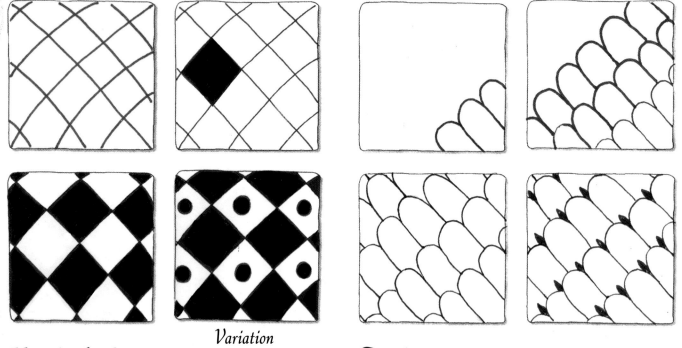

Knightsbridge*

Variation

Tagh*

*original Zentangle design

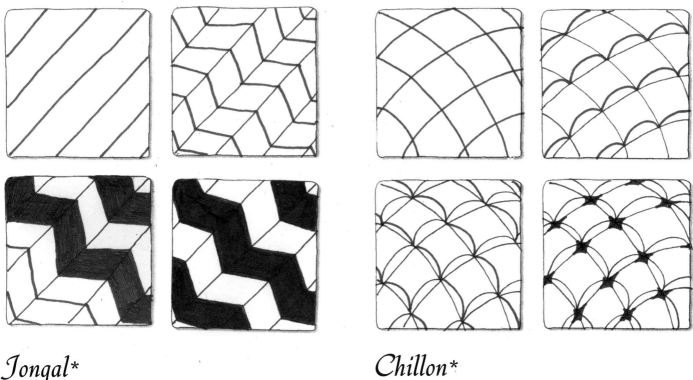

Jonqal*

*original Zentangle design - Variation

Chillon*

*original Zentangle design - Variation

Knightsbridge Swirl Tagh Queen's Crown

Fence

Variation

Waves

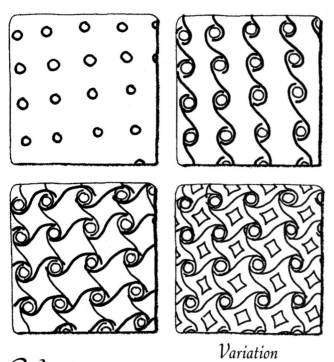

Cadent*

Variation

*original Zentangle design - Variation

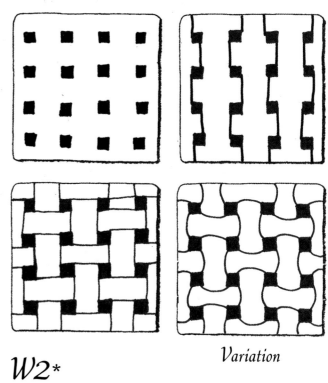

W2*

Variation

*original Zentangle design

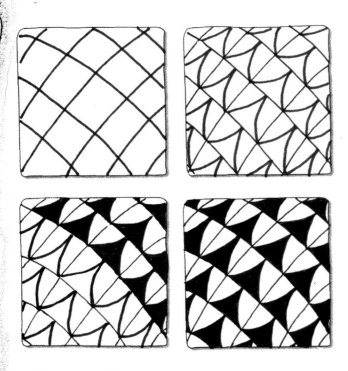

Flying Geese

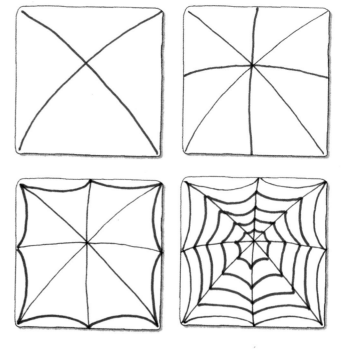

Web

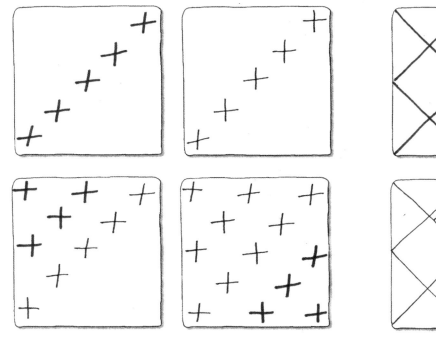

Cross Stitch

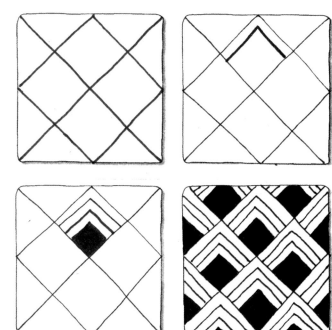

Flukes*

*original Zentangle design - Variation

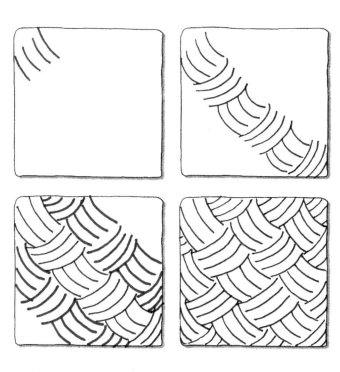

Keeko*

*original Zentangle design

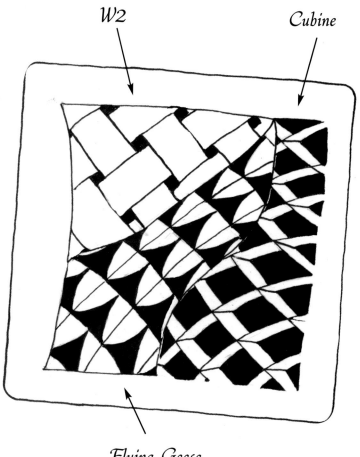

W2

Cubine

Flying Geese

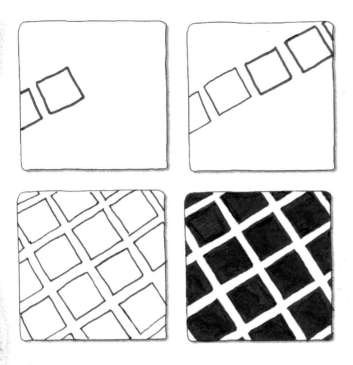

Squares

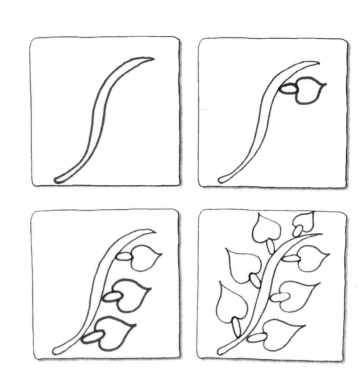

Growth

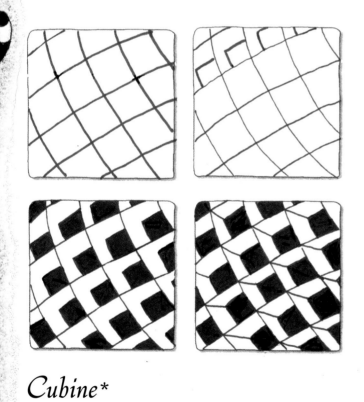

*Cubine**

*original Zentangle design

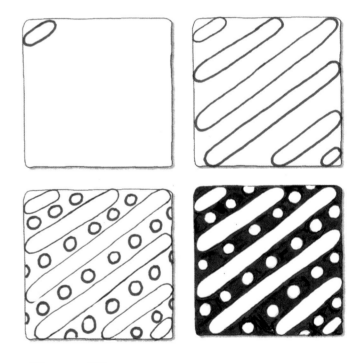

Corn Rows

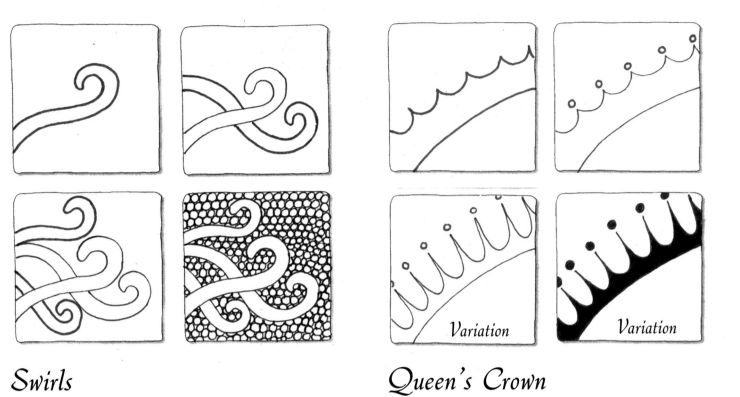

Swirls

Queen's Crown

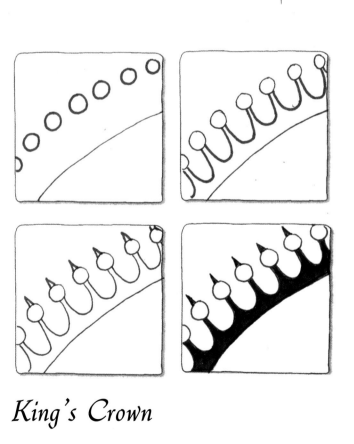

King's Crown

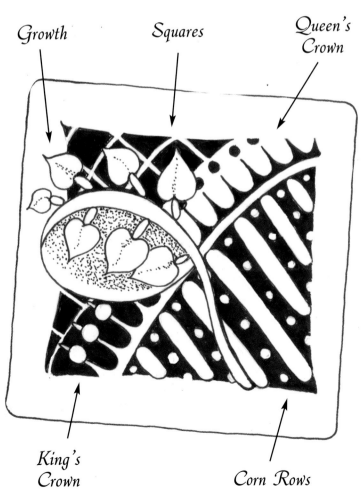

Growth

Squares

Queen's Crown

King's Crown

Corn Rows

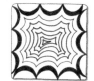
Crescent Moon*
page 5

Printemps*
page 6

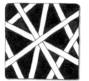
Hollibaugh*
page 6

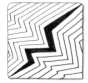
Static*
page 6

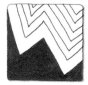
Chartz* Adaptation
page 12

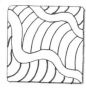
Waves
page 12

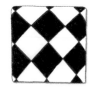
Knightsbridge*
page 12

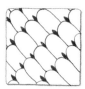
Tagh*
page 12

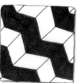
Jonqal*
page 13

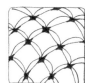
Chillon*
page 13

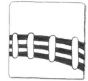
Fence
page 13

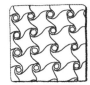
Cadent*
page 14

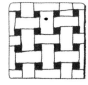
W2*
page 14

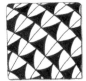
Flying Geese
page 14

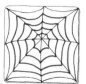
Web
page 14

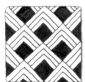
Flukes*
page 15

Cross Stitch
page 15

Keeko*
page 15

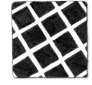
Squares
page 16

Growth
page 16

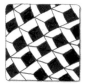
Cubine*
page 16

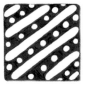
Corn Rows
page 16

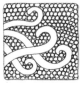
Swirls
page 17

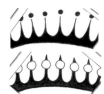
Queen's Crown
King's Crown
page 17

*original Zentangle design

Where to find more patterns...

Start with the basic patterns in this book. Then check out books two and three. More designs can also be found at zentangle.com in the newsletters and gallery.

Also look at quilts, books, furniture, nature, illustrations and the bottoms of sport shoes ... wonderful patterns and designs are everywhere.

I learned about "Zentangle" when my friend Mary Ann White emailed a link to a website along with, "Here's something you might like..." I went to zentangle.com and ordered a kit right away. I love drawing Zentangle patterns.

Gayle Bunch is an innovative elementary art teacher. Gayle suggested many of the wonderful educational ideas in this book.

My enthusiasm really blossomed when I attended a seminar and workshop taught by the Zentangle originators, Maria Thomas, a calligraphy artist and Rick Roberts, a former monk.

I hope you enjoy Zentangle as much as I do.